THIS JOURNAL BELONGS TO.

Harry Potter...

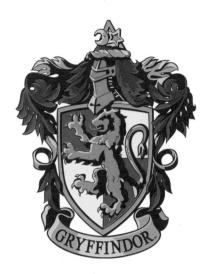

COURAGE

A GUIDED JOURNAL FOR EMBRACING YOUR INNER

GRYFFINDOR™

C-1/2

INTRODUCTION

COURAGE. BRAVERY. DETERMINATION. These are the traits of Gryffindor house, the bravest house at Hogwarts, emblazoned in their bold colors of red and gold and represented by a roaring lion. There are many notable and beloved Gryffindor characters in the Harry Potter films. From Harry Potter and Professor Dumbledore to the deceitful Peter Pettigrew, Gryffindors are represented by a wide range of witches and wizards. But what does it mean to truly be a Gryffindor? How can you bring out your natural qualities of courage, bravery, and determination and apply them to your everyday life?

This journal, composed of 52 weeks of prompts, will help you reflect on, connect with, and develop the Gryffindor inside you. Each week includes two kinds of prompts. The first is a simple form where you can record daily acts of courage, bravery, and determination. Taking the structure of a simple "one-line-a-day" journal, this form allows you to record small "Gryffindor moments" that you encounter throughout your week. There is no pressure to fill one out every day. After all, you might not have the opportunity to be courageous every day. But it gives you an opportunity to notice and note small ways that you embody your Gryffindor persona. The second prompt goes deeper, referencing specific quotes, moments, places, or characters from the films and inviting you to think about how being a Gryffindor shapes and affects your life. These prompts include freewriting, letter writing, list making, coloring, and more.

The Harry Potter films have inspired us, now it's time to explore further and embrace your inner Gryffindor.

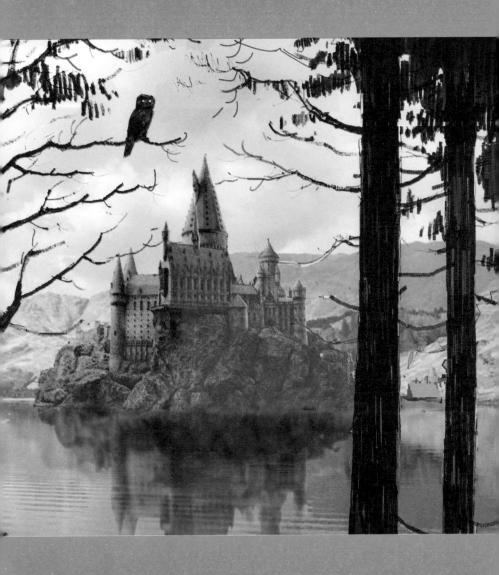

GRYFFINDOR MOMENTS:

Monday	
Tuesday	
	,
Wednesday	

Thursday	
\sim	
Friday	
Saturday	
0	
Sunday	

GRYFFINDORS, LIKE HARRY, RON, and Hermione—not to
mention Professor Dumbledore—use courage, bravery, and determination
to accomplish their goals. By purposefully embracing your inner Gryffindor
qualities, you are taking active steps to realize your dreams. What are you
hoping to achieve or discover by using this journal? How do you see your
Gryffindor traits helping you do this?
, , , , , , , , , , , , , , , , , , , ,
> ₢
♦
♦

GRYFFINDOR MOMENTS:

	6 3		
	6-11-3		
Monday			
		10	
7			
Tuesday			
Wednesday			

Thursday		
		*
Friday		
Saturday		
Sunday		

COLORING MEDITATIONS

The Sorting Hat sorts each Hogwarts student into their house on their first night at school, taking into account their background, talent, personalities, and personal choice. Due to your courage, bravery, and determination, you are a Gryffindor. Color in the hat below, and decorate the rest of the page with iconography and embellishments that represent your identity as a Gryffindor.

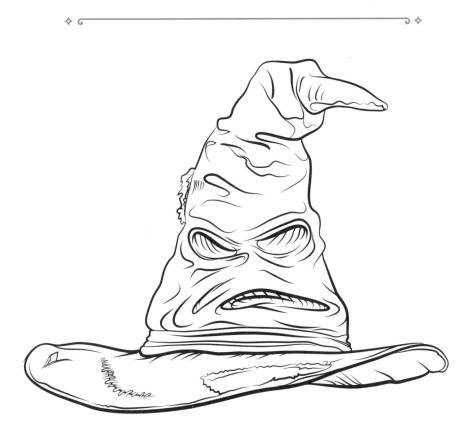

GRYFFINDOR MOMENTS:

_
\

Monday		
Tuesday		
		ě
Wednesday		

Thursday			
Friday			
	i i	1	
Saturday			
Sunday			
			5

	-
IN HARRY POTTER AND THE SORCERER'S STONE, Harry dis	covers
the Mirror of Erised in an unused classroom at Hogwarts. When he	looks
into it, he sees his parents. As Professor Dumbledore later explain	s, the
mirror shows the viewer whatever their heart most desires. What d	lo you
think you would see if you looked in the mirror? Do you see a conn	ection
to your identity as a Gryffindor? What is it?	
, , ,	
· G	
*	
*	
. 💠	

GRYFFINDOR MOMENTS:

Monday			
			•
Tuesday			
	A		
Wednesday			

Thursday		
Friday		
Saturday		
Sunday		

· C		
	THERE ARE MANY AMAZING Gryffindor characters in the	
	Harry Potter films. Who is your favorite? In what way do you think	
	this character embodies the traits of the house?	
6		_
-		
	A	
>	Υ	
` ◀	>	
-	·	

GRYFFINDOR MOMENTS:

11,
11/
11.
11/
1.

Monday			
		*	
Tuesday			
,			
Wednesday			

Thursday			
0			
Friday			
Saturday			
Sunday			
	4)		
			5

It's important to celebrate our victories.

Make a list of five recent accomplishments you achieved that you believe would earn you points for Gryffindor. Award yourself with the number of points you think you earned. Good job!

	,	
		oints:
	-/3	oinis:
	P.	oints:
t		
	P	oints:
		pints:
		ruruus;
	\bigcirc	rint.

GRYFFINDOR MOMENTS:

Monday		
Tuesday		
Wednesday		

Thursday		
Friday		
Saturday		
Sunday		
		440
		- 5

0		- 6
	ON HARRY'S FIRST DAY AT HOGWARTS, he and Ron	
	get lost and are late to class. As a Gryffindor, imagine how you	
	would spend your first day at Hogwarts.	
	, , ,	
6		
	>	
<u>٠</u>		
^	/	

		1
		100

GRYFFINDOR MOMENTS:

Daily Acts of Courage, Bravery, and Determination	
Monday	
Tuesday	
Wednesday	

Thursday	
Friday	
Saturday	
Sunday	

OUR SKILLS AND TALENTS often reflect the inner qualities we naturally possess. For example, Harry is a skilled flier, a talent that could be said to reflect the Gryffindor traits of daringness and nerve.

What specific skills and talents do you possess, and how do you feel they relate to your qualities as a Gryffindor?

ABOVE: Concept art of Harry and the Firebolt by Dermot Power.

	2		

	,	

THIS PAGE: Concept art by Adam Brockbank.

GRYFFINDOR MOMENTS:

Monday	
Tuesday	
Wednesday	

Thursday			
Friday			
Saturday			
	·		
Sunday			
			1

PROFESSOR MCGONAGALL IS THE HEAD of Gryffindor house during Harry's time at Hogwarts. There is no question that teachers, particularly those we work closely with, have a huge effect on the kind of person we grow up to be. Write a letter to your "head of house"—a teacher or mentor who helped you develop your Gryffindor qualities—reflecting on what they taught you and thanking them for being part of your journey.

			,
			
*			
A			
\checkmark			

\Diamond	
	\diamondsuit

,	
	,

GRYFFINDOR MOMENTS:

7/1	Daily Acts of Courage, Bravery, and Determination	
Mon	rday	
Juesa	lau	
	oug	
	*	

Wednesday

Thursday				
			,	
	,			
Friday				
Saturday				
unday				
				· #

PROFESSOR REMUS LUPIN	comes to Hogwarts in Harry					
Potter and the Prisoner of Azkaban to b	e the new Defense Against the					
Dark Arts teacher. How do you think Professor Lupin's qualities as a						
Gryffindor are represented in his persor						
think you could learn from him, both a						
trillik you could learn from fillin, both a	is a Grynmaor and as a person.					
G						
÷						
`^						
V						

	
*	\diamond

· ·	

GRYFFINDOR MOMENTS:

Daily Acts of Courage, Bravery, and Determination	
Monday	
Tuesday	
·	
Tuesday	

Wednesday

Thursday				
į.			3	
Friday				
Saturday				
Sunday				
	,			
			*	

"We've all got both light and dark inside us. What matters is the part we choose to act on.

That's who we really are."

-Sirius Black, Harry Potter and the Order of the Phoenix

Sirius Black speaks this powerful quote to Harry in Harry Potter and the Order of the Phoenix at a moment when Harry is feeling scared, anxious, and insecure in his identity. This quote could interpreted to mean that we all have our strong points and our weak points, our positive attributes and our flaws. Gryffindors are usually described as courageous, brave, and determined. Taken in another light, this could be interpreted as reckless and impulsive. Think about two moments in your life, one where your behavior reflected the "light" side of Gryffindor and one where it reflected the "dark" side. Describe these events on the following page.

What can you learn from them?

Light:	
Tight:	
Q g. c.	
Y X 1 1 1 1 1 1 1 1 1 1 1 1 1 1 1 1 1 1	
TRANSTRAN	
	X KANZO
	Z X X X X X X X X X X X X X X X X X X X
Dark:	

GRYFFINDOR MOMENTS:

	6
	1//
1	11/

Monday		
Tuesday		
Wednesday —		
Ţ.		

Thursday		
(hursdan		
- Jrow osway		
0		
\rightarrow . ρ		
Friday		
J		
\mathcal{O}		
O , \circ		
Saturday		
) we way		
\circ		
Sunday		
Jaroung		
Sunday		
		544
		Carried A
		4
		7

	IN HARRY POTTER AND THE HALF-BLOOD PRINCE,
	Fred and George Weasley finally achieve their long-term goal of
	opening their own joke shop. Write down three long-term goals you
	are currently working on. How do you see your assets as a
	Gryffindor helping you accomplish these aspirations?
Ψ 6	
1.	
0	
۷.	

		-	
,			
		V	
	9		

GRYFFINDOR MOMENTS:

Monday		
Tuesday		
Wednesday		

Thursday			
Friday			
-			
Saturday			
0 4			
Sunday			

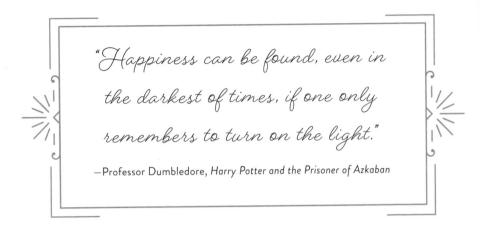

List ten things that bring joy to your Gryffindor heart.

Refer back to these when you are experiencing times of trouble or stress.

2. 3.
3
3
4
*
♦

5			
6			
~			
7			
O			
δ			20
	2		
9			
9			
10			
¥			

GRYFFINDOR MOMENTS:

Monday		
Tuesday		
v		
Wednesday		

Thursday		
Friday		
Saturday		
	ž.	
Sunday		

IN HARRY POTTER AND THE SORCERER'S STONE,

Neville Longbottom tries to prevent Harry, Ron, and Hermione from leaving the Gryffindor common room when they're sneaking out to find the Sorcerer's Stone. Worried that his friends will get Gryffindor into trouble again, Neville even goes so far as to try to fight them to keep them from leaving. Do you think Neville made the right decision in that moment? Knowing what he knew at the time, would you have made the same choice? Why or why not?

G		
G		
•		
*		
~		
A		
. ~		
Α. Α.		

		÷ 🌣
	u u	

GRYFFINDOR MOMENTS:

Monday		
	,	
Tuesday		
Wednesday		

Thursday	
Thiday	
Friday	
Saturday	
<i></i>	
Sunday	

COLORING MEDITATIONS

It's time to show some House Pride. Color the Gryffindor crest below, and decorate the rest of the page with embellishments and decorations of your choosing.

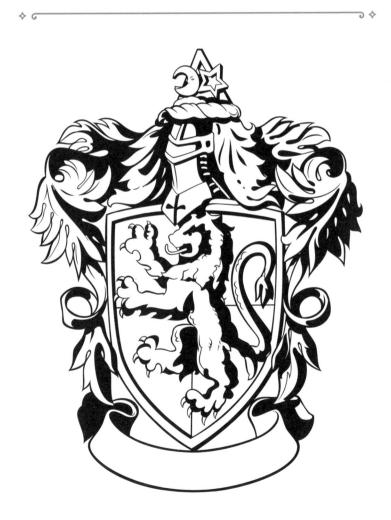

GRYFFINDOR MOMENTS:

Monday		
Tuesday		
Wednesday		

Thursday			
Friday			
Saturday			
Sunday			
		4	No.
			R. C.

IN	I THE HARRY POTTER FILMS, Harry Potter and Draco			
Malfoy are bitter rivals. Have you ever had a rivalry with another person?				
Were they in the same house as you or a different one? What about this				
person clashed with your traits as a Gryffindor?				
G				
	· · · · · · · · · · · · · · · · · · ·			
~ -				
♦				
₩				

GRYFFINDOR MOMENTS:

Monday		
Ţ.		
Tuesday		
Wednesday		
		,

Thursday	
Friday	
Saturday	
Sunday	
	, S & C

HOGWARTS CASTLE IS A MASSIVE, ancient building filled with classrooms, student living spaces, soaring bridges, deep dungeons, high towers, moving staircases, and more than one secret room. Which aspect of the castle would you be most eager to explore? Do you see a connection between this choice and your identity as a Gryffindor? How so?

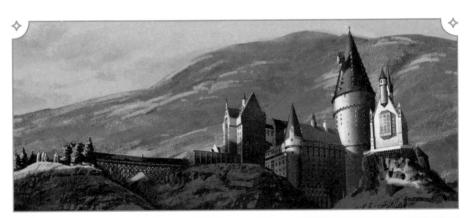

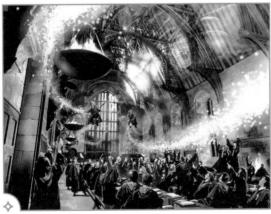

ABOVE: Concept art of the exterior and interior of Hogwarts castle by Andrew Williamson.

,

·	

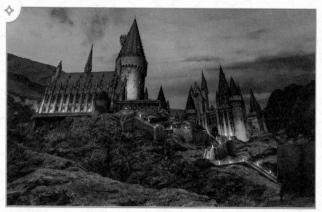

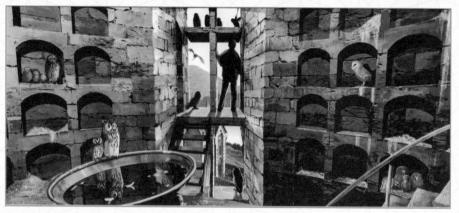

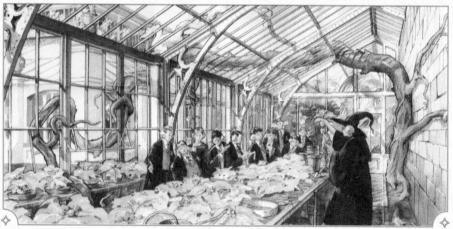

CLOCKWISE FROM TOP LEFT: The exterior of Hogwarts castle by Andrew Williamson; a concept piece of the stained glass window in the prefects' bathroom by Adam Brockbank; a study of the Owlery by Andrew Williamson; a concept sketch of the second-years in Greenhouse Three by Andrew Williamson.

GRYFFINDOR MOMENTS:

Monday		
Tuesday		
Wednesday	9	
	,	

Thursday		
		-
7		
Friday		
Caturday		
unday		
,		
		- 5

¢ c		٥
	IMAGINE YOU HAVE THE OPPORTUNITY to interview one Gryffindor from the Harry Potter films. Who would you choose? Write ten questions you would ask them.	
ф G	10 QUESTIONS FOR:	9
1.		
2.		
3.		
4.		

\Diamond	
	

5		
6		
7		
,		
8		
0.	i i	
9		
10		

GRYFFINDOR MOMENTS:

11/	

Monday			
Tuesday			
Wednesday			

Thursday		
Friday		
Saturday		
Sunday		
		,566.
		7

PETER PETTIGREW WAS A GRYFFINDOR and close friend of Harry Potter's father, James. Despite being a Gryffindor, Pettigrew made some choices that went against the qualities usually associated with the house—namely, his decision to betray Lily and James to Voldemort when Harry was just one year old. Have you ever made a choice that went against your house's traits? Why?

Describe the circumstances below.

-	
A	
V	
_	
~	
¥	
A	
♦	
, 	
*	
* * *	

GRYFFINDOR MOMENTS:

	6-1-3	
Monday		
	,	
Tuesday		
Wednesday		

Thursday	
Friday	
Caturday	
	e
unday	

IN THE HARRY POTTER FILMS, family members are often—but not always—placed in the same houses. While all of the Weasleys are in Gryffindor and all of the Malfoys are in Slytherin, characters like Sirius Black and Parvati and Padma Patil are placed in different houses than other members of their family. What houses would your parents and siblings belong to and why? How do you think this might have contributed to your being a Gryffindor?

4

G			
\$			
*			
>			
*			
^			
*			

		0	

GRYFFINDOR MOMENTS:

NENTS:	1/2
Determination	11/
	6

Monday			
Tuesday			
	a .		
Wednesday			

Thursday		
Friday		
		r.
Saturday		
Sunday		
) wrowy		
		(she

"Words are, in my not-so-humble opinion, our most inexhaustible source of magic. Capable of both inflicting injury and remedying it."

-Professor Dumbledore, Harry Potter and the Deathly Hallows - Part 2

WORDS MATTER.

Write a mantra to help you tap into your inner Gryffindor.

Use the space below to draft your thoughts and write the final version in the shield on the opposite page.

MY GRYFFINDOR MANTRA

7/1	GRYFFINDOR MOMENTS:	11/
7/1	Daily Acts of Courage, Bravery, and Determination	11/
Į.		6
Mo	rnday	

Tuesday			
Jeresery			
		*	
Wednesday			
Deuresaug			

Thursday		
Friday		
Saturday		
	_	
Sunday		
		3

"Welcome to Hogwarts. Now in a few moments, you will pass through the doors and join your classmates, but before you can take your seats, you must be sorted into your houses. They are Gryffindor, Hufflepuff, Ravenclaw, and Slytherin. Now while you're here, your house will be like your family."

Think about your closest friends.

What houses do they belong to? Are they the same as you?

How does this affect your relationships?

-Professor McGonagall, Harry Potter and the Sorcerer's Stone

GRYFFINDOR MOMENTS:

1//
-
11/
6

Monday			
	A		
Tuesday			
Wednesday			

Thursday			
Friday			
	,		
Saturday			
,			
	-		
Sunday			
			44-
		,	

< С	
, –	THINK ABOUT YOUR OWN SOCIAL INTERACTIONS
	as a "typical" Gryffindor. Write about a time you and your friends
	acted like Gryffindors. What did you do? Why is this particular
	memory valuable to you?
ф G	
	*
\$	
٠, ١	♦
~	w

	
*	

	,	

7/	GRYFFINDOR MOMENTS:	1//
7/1	Daily Acts of Courage, Bravery, and Determination	11/
ي		
Mo	rnday	

Tuesday			
, westung			
Wednesday			

Thursday		
•		
		,
Friday		
2		
Saturday		
	~	
γ		
Sunday		

In the Harry Potter films, the Sorting Hat was originally planning to put Harry in Slytherin, but he pleaded with the hat not to, and the Sorting Hat accepted his choice. Given the choice, would you choose to be in Gryffindor? Why or why not?

GRYFFINDOR MOMENTS:

၉
1//
1//
11.
' '
b

Monday		
Tuesday		
Wednesday		

Thursday			
Friday			
Saturday			
Sunday			
			Mile.
			1

IN HARRY POTTER AND THE SORCERER'S STONE, Harry,
Ron, Hermione, and Draco Malfoy are caught out of bed at night and
sentenced to detention in the Forbidden Forest. Imagine you've been
sentenced to detention at Hogwarts. Based on your personality as a
Gryffindor, what rules do you think you'd be most likely to break and why
G
•
A
>
♦
•

			ฏิ	
	1	1	1	
-	7	-/,	1	
	/	/	1	
			U	

GRYFFINDOR MOMENTS:

	(>-)	
	6-11-3	
Monday		
) V (or early		
Tuesday		
Wednesday		
0		

Thursday		
- Mursdau		
) rece escency		
O		
	-	
7 . 1		
tridau		
Friday		
U		
Ω , Ω		
Saturday		
) cold deleg		
2		
'undou		
Juruuy		
Sunday		
		44=
		ill.
		(3)
		1
		*

IN HARRY POTTER AND THE PRISONER OF AZKABAN,

Professor Lupin teaches the third-year students how to repel a Boggart, a
Dark creature that takes the form of whatever the person fears the most.
Do you have any specific fears that relate to your identity as a Gryffindor?
Fear of failure? Fear of boredom? Fear of spiders? Write these down here.
On the following page where it reads "Riddikulus!" write what you would use to repel the Boggart if it turned into what you fear.

ABOVE: The Boggart version of Potions Master Severus Snape, dressed as Neville Longbottom's grandmother. Design by Jany Temime, drawn by Laurent Guinci.

Riddikulus!		
, (
		-
	1	
		*

ABOVE: Concept art of the jack-in-the-box version of the Boggart by Rob Bliss.

GRYFFINDO

Daily Acts of Courage,

OR MOMENTS:	1/2
Bravery, and Determination	11/
- > - 0	b

Tuesday Wednesday	Monday	
	Tuesday	
Wednesday		
	Wednesday	
		N

Thursday				
			8	
Friday				
	,			
		. ,		
Saturday				
Sunday				
-				
				J. F.

to relate	to. What is i	t about tha	at house th	nat you, as a	Gryffindor,
	find diffic	ult to und	erstand or	appreciate?	

· · · · · · · · · · · · · · · · · · ·	

GRYFFINDOR MOMENTS:

()
1//
-
11/
b

Monday		
Tuesday		
Wednesday		

Thursday				
			7	
Friday				
Saturday		u.		
Sunday				
				. 4
				2

	THE GRYFFINDOR COMMON ROOM is a large,
	comfortable room decorated with cozy red couches, a roaring fire,
	and rich tapestries. Look around your own living space. What items
	or elements do you feel reflect your tastes as a Gryffindor?
٠ <i>ح</i>	
♦	
♠	
٠ 💠	
	*
	·

GRYFFINDOR MOMENTS:

()
1//
11//

Monday		
Tuesday		
Wednesday		

Thursday			
Friday			
	,		
		,	
Saturday			
			·
Sunday			

THE HARRY POTTER FILMS ARE FILLED with examples of romantic pairings between people from different houses, such as Lupin and Tonks, Harry and Cho, and Neville and Luna. Consider your ideal romantic partner. Are they in the same house as you?

What house do they belong to and why?

•		
A		
<>		
*		
. 52		
♦ W		
♦		

	 6	
,		

			6	
	\	1	1	
-	$\overline{}$		<	
	1	1	1	
			e	

GRYFFINDOR MOMENTS:

Monday			
			_
Tuesday			
		ž	
Wednesday			
	,		

Thursday			
		,	
Friday			
			,
Saturday			
	-		
Sunday			
			, Mar.
			3

IMAGINE YOUR HOUSE JUST WON the House Cup.

How would you celebrate? Use this space to jot down some ideas
for the perfect House Cup party that Gryffindors everywhere

would love to attend.

* *		
A		
♦		
A .		
. <>		
♦ ▼		

		า	
	1	71	
-	=	: 1	
	/	/1	
		وا	

GRYFFINDOR MOMENTS:

Monday		
Tuesday		
Wednesday		

Thursday			
Friday			
Saturday			
		,	
Sunday			

	WHEN FIRST-YEAR HOGWARTS STUDENTS are sorted into their houses, they are only eleven years old. Do you think you would have been sorted into Gryffindor when you were eleven? How have you changed or grown since then?
· 6	
	·
	,
79	
	*
	
*	
	A

	*	
3		
	-	

GRYFFINDOR MOMENTS:

Monday		
Tuesday		
Wednesday		

Thursday		
Friday		
20		
Saturday		
Gunday		

IN HARRY POTTER AND THE HALF-BLOOD PRINCE, Harry is given the task of retrieving a memory from Professor Slughorn. This poses a bit of a problem as the reluctant professor does his best to avoid Harry once he realizes what Harry's trying to do. Harry eventually solves the problem by taking a dose of Felix Felicis and appealing to Slughorn's memory of Harry's mother. As a Gryffindor, how do you solve problems? When was the last time you used your Gryffindor qualities to solve a problem and how?

> G	১
>	
A .	
	
* *	
* Y	

GRYFFINDOR MOMENTS:

Monday		
Tuesday		
Wednesday		

Thursday			
Friday			
Saturday			
	*		
Sunday			
			5

IN HARRY POTTER AND THE ORDER OF THE PHOENIX,

Harry mistakenly believes a vision sent to him by Lord Voldemort that shows his godfather, Sirius, in danger. Harry rushes to his godfather's aid, an action that eventually leads to Sirius's death. Think about the last time you made a mistake. Were there any aspects of your identity as a Gryffindor that played a part in the situation? What could you have done differently?

G				9
		(f		
\$				
			9	
·				
♦				

	V		
,	e - ç	,	

1	١	- 1	
_	/	'	
-	-		
	/	1	l

GRYFFINDOR MOMENTS:

Thursday		
Friday		
Saturday		
Sunday		

Everyone has special places in their lives.

Places where they feel the most like themselves. For Harry, this is Hogwarts. Think about a space that is important to you as a Gryffindor. How does this space bring out those qualities that symbolize your inner Gryffindor?

2
· .

GRYFFINDOR MOMENTS:

Monday			
Tuesday			
		,	
Wednesday			
	16		

Thursday	
Friday	
0	
4 , 0	
aturday	
unday	

IN HARRY POTTER AND THE GOBLET OF FIRE, Harry faces a Hungarian Horntail guarding a golden egg as the first task in the Triwizard Tournament. He uses his broomstick to complete the task, a decision that plays into his assets as a Gryffindor. How would you use your Gryffindor qualities—courage and nerve—to achieve this task?

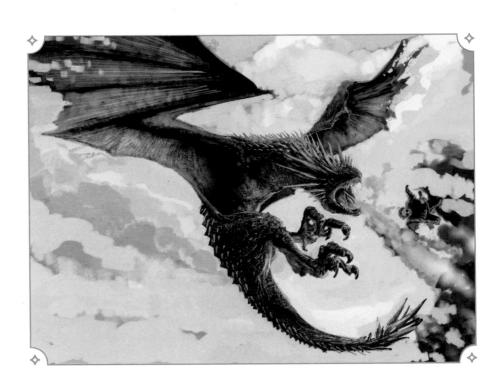

ABOVE: Concept art of Harry battling the Hungarian Horntail by Paul Catling.

	TI CONTRACTOR OF THE CONTRACTO	
	-	
		4

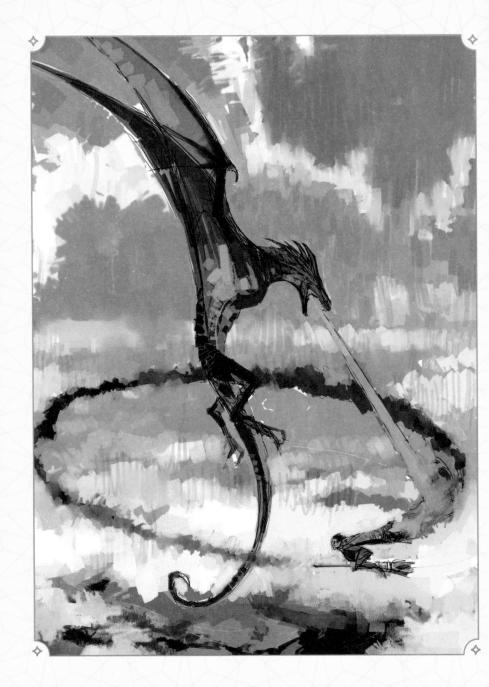

ABOVE: Concept art of Harry and the Hungarian Horntail by Dermot Power.

				41		
					16	
			*	,		
	8	147				
-						
,,						
,						

GRYFFINDOR MOMENTS

MENTS:	1/2
Determination	

Monday		
Tuesday		
,		
Wednesday		

Thursday				
Friday				
		-		
Saturday				
			а	
Sunday				
				*
			*	

IN HARRY POTTER AND THE CHAMBER OF SECRETS, Harry discovers he can speak Parseltongue, a skill that frightens him due to its association with Dark wizards. Have you ever discovered something about yourself that frightened you? How can you use your assets as a Gryffindor to overcome that fear?

GRYFFINDOR MOMENTS:

Monday			
			,
Tuesday			
	7		
Wednesday			

Thursday			
- Jrow isway			
Friday			
Friday			
Saturday			
			1
		19	
Sunday			
Jarrang			
			544
			1
			N. E.

	WHILE LIFE IN THE HARRY POTTER FILMS never lacks excitement, in the real world, we all get bored from time to time. But boredom can be addressed with just a little creativity. Make a list of ten things you can do right now to challenge, interest, or inspire your inner Gryffindor. Refer back to this the next time you need some inspiration.
\$ G	9
1.	
2.	
3.	
	-
46	

5				
6				
~				
7				
8				
0				
9				
10				

GRYFFINDOR MOMENTS:

P
11/
1//
>-
11
11/
1
6

Monday			
Tuesday			
Wednesday			

Thursday			
7 . 1			
Friday			
Saturday			
		8	
Sunday			
			. #
			2

COLORING MEDITATIONS

The Sword of Gryffindor is an iconic Gryffindor artifact that is known to appear to Gryffindors when they have a great need for it.

What artifacts in your own life represent your identity as a Gryffindor?

Color in the sword below, and then decorate the rest of the page with illustrations, taped or glued-in ephemera, or other embellishments that symbolize these artifacts.

GRYFFINDOR MOMENTS:

Monday			
Tuesday			
Wednesday			

Thursday		
U		
Friday		
Saturday		
-		
Sunday		

"For in dreams we enter a world that is entirely our own. Let them swim in the deepest ocean or glide over the highest cloud."

-Professor Dumbledore, Harry Potter and the Prisoner of Azkaban

Our dreams can reveal a lot about our inner world.

Write down a recent dream you had and how it relates to your identity as a Gryffindor.

	*	

GRYFFINDOR MOMENTS:

Monday	
Tuesday	
Wednesday	

Thursday		
-		
~ .		
Friday		
0		
Saturday		
) 0		
Sunday		
) ar tolog		
		3

refect at Hogwarts. ears in Gryffindor. d give them to help identity.
ears in Gryffindor. d give them to help identity.
d give them to help identity.
identity.
→ •

17			
4	,		
5			
<i>O</i> .			
		*	

GRYFFINDOR MOMENTS:

6
1//
-
11/
6

Monday		
,		,
Tuesday		
Wednesday		

- Shursday		
Friday		
<i>O</i>		
Saturday		
		-
Sunday		
) 0		

IN THE HARRY POTTER FILMS, Harry encounters many
adult figures who he looks up to and respects—Remus Lupin, Minerva
McGonagall, and even Severus Snape—who help shape his development
into a hero. Think about a real-world Gryffindor in your life who has
inspired you. What about this person do you most admire and respect?
> G
÷
^
♦ ◆

\$	
	

	,			
			1.	
,				
			, a	

GRYFFINDOR MOMENTS:

Monday		
Tuesday		
Wednesday		

Thursday			
		12	
~			
Friday			
C + , 1			
Saturday			
Sunday			
Sunday			
			- (#

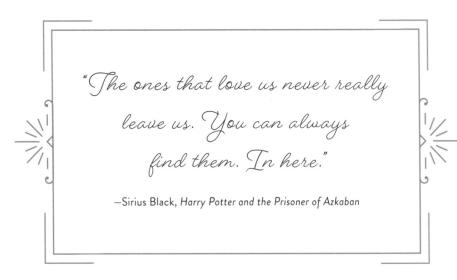

Think about someone you've lost in your life, either through death or another circumstance. Reflect on your relationship with that person and what they taught you. Did they play any part in your development as a Gryffindor? How so?

GRYFFINDOR MOMENTS:

Monday		
Tuesday		
Wednesday		

Thursday		
Friday		
Saturday		
Sunday		
		3

THE WIZARDING WORLD IS FULL of an astonishing array of magical creatures: dragons, Hippogriffs, house-elves, centaurs, phoenixes, and more. What creature do you think embodies traits similar to those of Gryffindor house? How can you bring the spirit of that creature into your daily life?

 $\label{eq:ABOVE LEFT: Concept art of a Thestral by Rob Bliss.}$ ABOVE RIGHT: Concept art of Fawkes the phoenix by Adam Brockbank.

		993	
	-		

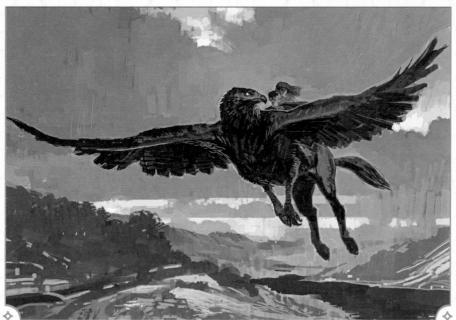

CLOCKWISE FROM LEFT: Concept art of Aragog in his lair by Adam Brockbank; a centaur draws his bow, also by Adam Brockbank; Harry riding Buckbeak the Hippogriff, art by Dermot Power.

GRYFFINDOR MOMENTS:

·				
Tuesday				,
		3	a ^r	
Wednesday				
Wednesday				

Thursday		
Transaug		
0		
7 0		
triday		
Friday		
$C \cap D$		
Saturday		
Constant		
Sunday		
		2006-
		(3)
		J. F

IN THE HARRY POTTER FILMS, there are moments of great danger and grief, especially in the later films as the wizarding world becomes enveloped in a devastating war against Lord Voldemort. In the real world, everyone deals with stress, pain, and emotional upheaval from time to time. That's why it's important to prioritize self-care.

As a Gryffindor, what does self-care mean to you? How do you take care of yourself when faced with stress or pain?

*			
>			
\Diamond			
· •			

	,	

			6	
	\	1	I	
_	_	-	1	
	1	//		
		/	ı	
			e	

GRYFFINDOR MOMENTS:

Monday		
Tuesday		
		×
Wednesday		

Thursday			
Friday			
	1		
Saturday			
Sunday			
		,	1

		9 -
	VOLUME HIGH LANDED A MALOD LOD INTERMEDIA	
	YOU'VE JUST LANDED A MAJOR JOB INTERVIEW.	
	How can you use your assets as a Gryffindor to get the job?	
	Make a list of five things you can do to prepare.	
♦ G		_ ∙
1.		
2		
~ '		
<		
\$		
, <	>	

3				
<i>O</i> ,				
				7
4				
	9			
5				
·				
			-	

GRYFFINDOR MOMENTS:

Monday		
Tuesday		
Wednesday		

Thursday	
\sim	
Friday	
Saturday	
,	
Sunday	
<i>O</i>	
	 No.
	 5

ТЫБ	RE ARE MANY GREAT EXAMPLES of Gryffindor heroes
	,
in th	e Harry Potter films: Harry, Ron, Hermione, Neville Longbottom,
and	many more. What do you think defines a Gryffindor hero? How
	can you, as a Gryffindor, be a hero to someone in your life?
	
\Diamond	
₩ ,	

		*
		T T
		y .
	9	

GRYFFINDOR MOMENTS:

Monday			
Tuesday			
Wednesday			

Thursday		
Friday		
Saturday		
0 0		
Sunday		
		3

IN HARRY POTTER AND THE CHAMBER OF SECRETS,
Draco Malfoy goads Ron Weasley into attacking him by calling Hermione
a foul name, an act that plays into Ron's Gryffindor qualities of chivalry
and determination. Has anybody ever used your traits as a Gryffindor
against you? How could you have handled this differently?
·
δ
♦
♦ ▼

<	♦

GRYFFINDOR MOMENTS:

Monday	
Tuesday	
Wednesday	

Thursday			
	0		
Friday			
Saturday			
Sunday			
			1

IN HARRY POTTER AND THE ORDER OF THE PHOENIX, Harry
•
and his friends start Dumbledore's Army, a secret student group dedicated to
fighting Dolores Umbridge's rules and learning practical Defense Against the
Dark Arts skills. As a Gryffindor, how can you stand up for what you believe
in? What kind of steps do you feel you can take to contribute?
, , ,
> G
*
*
♦ ¥

GRYFFINDOR MOMENTS:

Monday
Tuesday
Wednesday

Thursday		
Friday		
Saturday		
	÷	
Sunday		
		8,

Think of a time you were in conflict with someone who embodies the characteristics of another house. How were you able to resolve the situation? Did your qualities as a Gryffindor prove to be an asset or an obstacle?

	ÿ	

GRYFFINDOR MOMENTS:

Tuesday Wednesday	Monday	
	Tuesday	
Wednesday		
	Wednesday	

Thursday		
The state of the s		
Friday		
Saturday		
Sunday		
Sunday		
		5

AS EVERYONE KNOWS, the traits of Gryffindor are courage, bravery, and determination. After fifty weeks of reflection and cultivation, which of
these traits do you identify with the most? Which do you identify with the
least? Are there any additional traits that you feel match the Gryffindor
profile that are not talked about as much?
*
*
. ♦
A

GRYFFINDOR MOMENTS:

Monday			
Tuesday			
Wednesday		,	

Thursday		
- Mursday		
Friday		
thiday.		
Julian		
O		
	*	
$C \perp I$		
Laturday		
Saturday		
0 1		
Sunday		
Sunday		
		664
		A Aller
		4

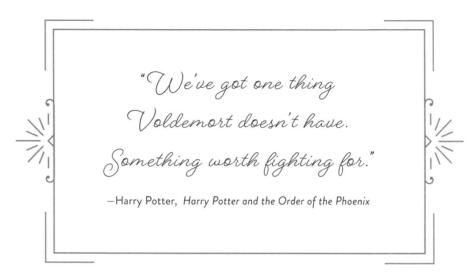

Everybody believes in fighting for something.

As a Gryffindor, what do you think is worth fighting for?

How do you fight for it?

8			
	-		
			*

GRYFFINDOR MOMENTS:

Monday
Tuesday
Wednesday

Thursday				
Friday				
Saturday	9	r		
Sunday				
- 0				
				5

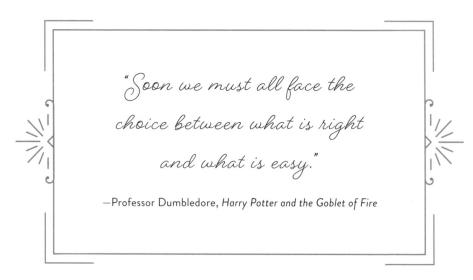

For the final prompt, reflect on what you've learned.

How do your qualities as a Gryffindor

help you make the right choices?

V.		
	,	
ū.		

PO Box 3088 San Rafael, CA 94912 www.insighteditions.com

find us on Facebook: www.facebook.com/InsightEditions

Follow us on Twitter: @insighteditions

Copyright © 2020 Warner Bros. Entertainment Inc. WIZARDING WORLD characters, names and related indicia are © & TM Warner Bros. Entertainment Inc. WB SHIELD: © & TM WBEI. Publishing Rights © JKR. (\$20)

All rights reserved. Published by Insight Editions, San Rafael, California, in 2020.

No part of this book may be reproduced in any form without written permission from the publisher.

Library of Congress Cataloging-in-Publication Data available.

ISBN: 978-1-64722-237-6

Publisher: Raoul Goff

Associate Publisher: Vanessa Lopez Creative Director: Chrissy Kwasnik VP of Manufacturing: Alix Nicholaeff Senior Designer: Ashley Quackenbush

Editor: Hilary VandenBroek

Editorial Assistant: Anna Wostenberg Managing Editor: Lauren LaPera Production Editor: Jennifer Bentham Production Manager: Andy Harper

Text by Hilary VandenBroek

REDI AN

Insight Editions, in association with Roots of Peace, will plant two trees for each tree used in the manufacturing of this book. Roots of Peace is an internationally renowned humanitarian organization dedicated to eradicating land mines worldwide and converting war-torn lands into productive farms and wildlife habitats. Roots of Peace will plant two million fruit and nut trees in Afghanistan and provide farmers there with the skills and support necessary for sustainable land use.

Manufactured in China by Insight Editions